A Beautiful Work of Heartistry

SOUL SOARING

BY VALERIE SAYRE

Cover Design: "Bodhicitta Heart" by Donna Iona Drozda

Illustrations: Page 41 "Birds"; Page 27 "Mother Earth"; Page 37 "Moon Illumination"; Page 72 "Transitions"; Page 74 "Reach Into Your Dreams"; all illustrations copyrighted by Donna Iona Drozda. All rights reserved.

Interior Design: Janie Lott

Published by: Youniversal Heart, LLC

Soul Soaring. Valerie Sayre. First Edition.

ISBN: 978-1-5136-9892-2

This book is dedicated to everyone who strives for resilience, beauty, connection, and joy during times of turmoil, challenges, and their own black grace.

Table of Contents

5. Spirit

Who doesn't want to soar? You likely picked up this book because you too have SOAR in your soul. For some reason you were drawn to this book. Maybe it was the author, Valerie Sayre; maybe you are familiar with her soul, her journey, or her angelic work in this earth venture. Or maybe you were drawn to the captivating cover that wrapped up your heart's joys, hurts, pleasures, and cocooned them into safety. Or is it that poetry speaks to your core with a fulfilling clarity? It is possible that it is all these reasons plus surprises of your own inner work.

No matter your reason for wanting to SOAR, you will find what you are looking for in "Soul Soaring".

It has been my pleasure to know and soar in life with Valerie Sayre for 25 years; that's a quarter of a decade. That's longer than most marriages last or children are fully educated. Brain experts report that it takes 25 years for our brains to fully develop. That's a relationship of deep value and reward. I am beyond grateful, and you are locking hearts and souls to join in this journey.

During our journey together, I have witnessed Valerie's search for a soul mate, loving and releasing with the usual pain and emptiness, landing in courage, self-pride, and joyful fulfilled love. Losing a child and nurturing four children shaped her soul with a depth only known to Valerie and others who have walked that path.

Through it all, we are always growing and reaching for our best version.

To soar, one must create the vessel that provides the blast. Valerie's way to create is to blast forward. Her momentum operates with a pace of its own, with a passion for others' success that can't be tampered down. Operating within an internal light speed often leaves frayed edges in relationships and conversations. Our edges open the doors and windows to soaring. The choice of how to receive life's lessons is always up to the individual.

Angelic spirit is infused in each poem that comes from Valerie's core and seeps from her aura. Valerie has lived in embrace of the Angels guiding her heart and soul. It is through Valerie's Angelic source that she has always found the softening of life's edges. Valerie soars in her own life as a Mom, Wife, Healer, Reiki Master, Nutrition Expert, and Global Impactor. She enriches the lives she touches with deeper meaning, clarity, vision, and health. Her nutritional healing work has shifted the life experience of countless humans! She reminds us to reach higher, live bolder, and grow beyond what we dared to claim as our peak!

The power of Valerie's words extends not only throughout her poetry but to all her dealings with others. She often gives back to others through the lost art of sending expressive and uplifting cards. Recently I had the pleasure of receiving a card from her that simply said, "Glad we can gallop to more and more greatness together!"

As you gallop through "Soul Soaring", you will explore page after page of Valerie's own soul that she shares with us while learning about your own along the way. Your journey through this soul-filling collection of poetry will not disappoint. May we all Gallop into Greatness together! Soar Away!

— Gay Russell, LCSW, Feeling Whole Counseling Services, Angelic Spirit Warrior

People

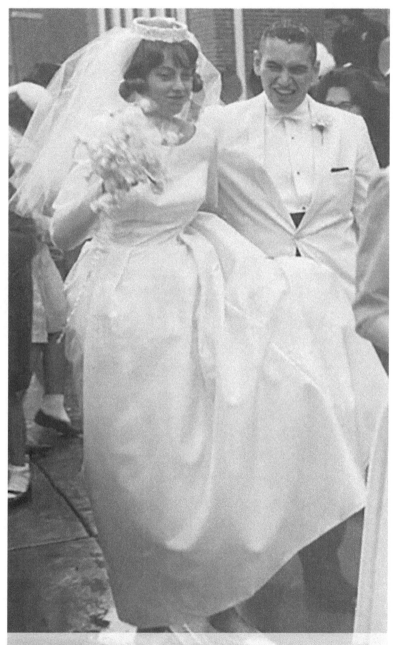

Robert & Barbara Popovic, October 10, 1964

Parents

Did they choose us?
Did we choose them?
Most likely we chose each other
Role models?
Maybe...maybe not
Deeper lessons
Every lifetime
A new contract
Wading through the dark hurts
Blundering at times
Trying to remember
We knew each other
Re-writing our stories
Re-writing our futures

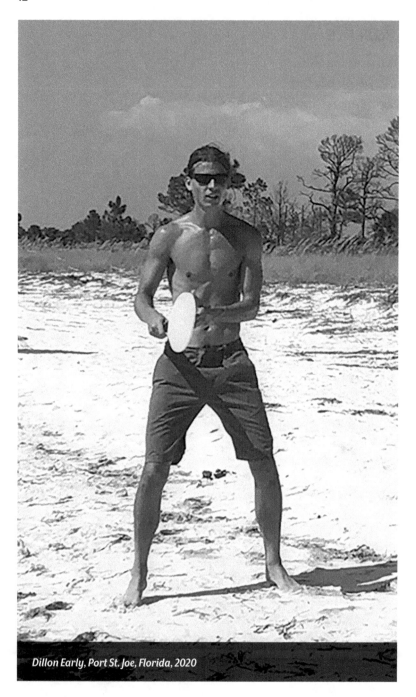

Dillon Early, Port St. Joe, Florida, 2020

Son

You grip my insides
Unwilling to leave the warmth
Rainforest sounds envelope us
The birds sing
You delay your presence
You are in charge
Finally, you decide to see the light
You are long and lean
There's an instant divine connection
Sacredness no one talks about
Unconditional love
We have a strong soul contract
The angels celebrate
The galaxies sparkle
The gods whisper
You are in my dreams often
Healing and curing lifetimes for each other
Adoring you always, Dillon

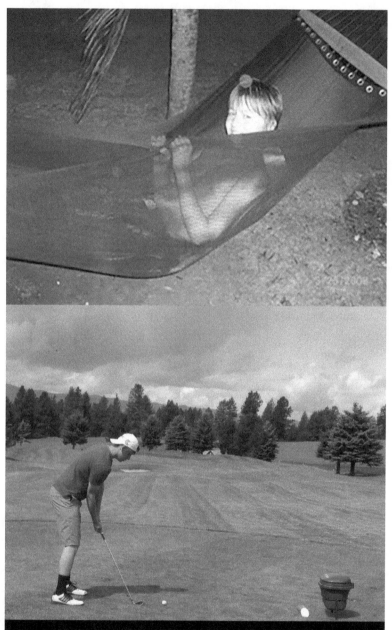

(Top) Preston Early, San Juan, Puerto Rico, 2008;
(Bottom) Preston Early, Golf Bliss, Montana, 2014

You Were

You were my first
Son
You were my first
Big loss
You were
Born knowing
Angels spoke to you early
You saw auras
You were
Sensitive and affectionate
You were
A daredevil with a
Wicked and intelligent sense of humor
A natural leader but
You chose audacious lessons that created
Shadows, addictions, and burdens
You escaped in nature; you couldn't stay there
Craving community
You couldn't escape or
Move on
Shame, regret, and worry
When sober and clear
You shared your inner secrets and hurts
Creating a sincere bond
Unconditional love between us
You taught me that lesson forever
Embracing the memories
Honored to be your mom
You were my sun
Preston
You are home

John and Valerie Sayre, Port St. Joe, Florida, July 26, 2018

My Beloved

Aching for us to find each other
Once I let go, you showed up
I knew you were there
Your walk, your smell, and your voice, familiar?!
Our first kiss was delicious
Slow, meaningful, and deep
Your eye contact drew me in
In sync and one from our first date
Trusting your intentions
Intoxicating interactions
Other suitors notified and turned away
Those magical words of love exchanged
Immersed in joining families
Past mistakes forgotten
Comparing gone
Rewriting our futures

New high standards
Holding, respecting, a team
Romance, friendship, and commitment
Loyalty, fun, and completing each other's dreams
Divine for now
There is no end

Magical Moments

Embrace them when they appear
A brilliantly colored dragonfly
Children giggling
Better yet, an adult laughing
Pay attention
They are all around you
The brush of touch
Holding hands with your lover
Your aging parents
A dream about a transitioned loved one
A new flavor that delights
Waking your spirit up
Be alert
A cool breeze on a hot day
Wake up

Valerie Sayre, Preston & Dillon Early, Lakewood, Ohio, 2009

Mothering

Thousands of highs and lows

A pain worth enduring

Heart-stopping worry and love

Expressing centuries of memories and actions

Untying the dysfunctional ties

Finally unbound joy or disconnection

Together for every meal and event

Separated to remind us we are here for our own soul's purpose

Missing, hoping, and guiding while allowing

Mistakes, broken hearts, and then self-love

Careers, travel, new families

Kids or no kids

Standing back to watch and enjoy

Sometimes offering home base for the broken parts and days

Aging parents bring memories, gratitude, and forgiveness

Secrets revealed

A determination to not repeat patterns

Stillness becomes peaceful

Death becomes a transition if you let it
Your parenting continues to transform
You can offer more
More consciousness
Appreciation for every journey
Letting it be
Becoming more
Destined to mother and transform
An empress

Heidi Sayre, Kona, Hawaii, June 2022

Coming Out of Hiding

Your spirit suppressed
Your heart crushed
Your voice limited
Your spine bent
Twisted obsessiveness

They will not prevail
You call for something better
A new connection
You peak into the dark at first
There is light
An opening to your soul
Bigger rays of sunshine sneak in
The crying starts
Emotional release
A loving teacher is trusted
You lean in
You found your spirit family again
Through my dreams
Connecting you to YOU
You call in your guides
Through cards and sincere desire
Reiki sparks your vibration
You nourish your physical body
Your auric field expanded and brightened
Attracting introspection
Calling in bliss
Grounding you to grandness
Shamanic teaching and books
Finding open, loving friends
Feeling the love now
Standing tall and breathing deeper
Now you can also emanate love
The gods are proud
We are proud
We can stand back
We admire you
We watch for you to teach us now
No more Heidi-ing

Sisterhood

Birthing the human race
Blood connection
Soul connection
Nurturing
Gentle
Compassionate
Angelic
Love
Divinity
Inner woman speak
We carry the infinite

My Mentor: Gay Russell, Austin, Texas, October 2019

Guru

A teacher
A mentor
A guide
A shepherd
A conductor
A leader
Service
Advising
Possibilities
Freedom
Ushering in peace
Filling up your heart
Love
Reverence

Nature

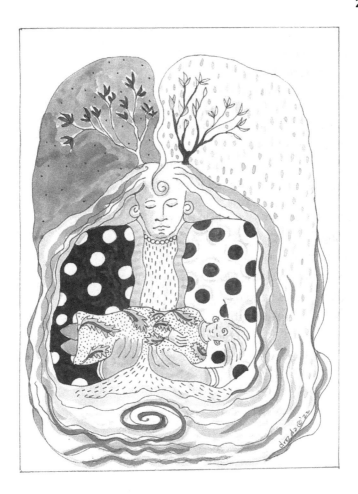

Mother Earth

She brings me comfort
The rocks glisten
Holding gems and crystals
Precious and old

Her ground under my feet comforts me
Her warmed stones on my body envelope me
My soul connects to her messages

Endless waves
Like our lifetimes
They can be restless and harsh or
Grounded, whole at peace

Her shells remind us of all the gifts
The beauty of the sea
Cleaned, collected, and vibrating on our shelves
They whiten with age like our human hair

The trees and leaves wrestle in the winds
Sending me whispers of timelessness
Proof of grounded delight
Growing, shedding the old, and then re-blooming
Bending, always bending
Thank you, Mother Earth

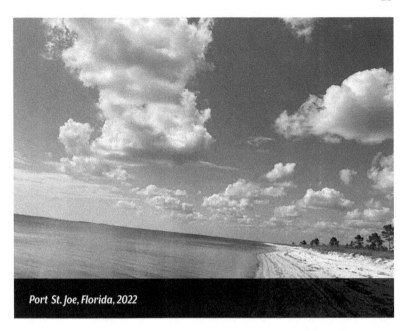

Port St. Joe, Florida, 2022

Waves

Waves of the sea

Waves of life

Prevail

One after another

Countable

Majestic

Recognized by all

Wait

Changing

Wet like tears of grief, love, and joy

Do You?

The stars twinkle, do you?
The moon shines brightly, do you?
The sea tells the truth, do you?

The wind sweeps away the dust
Do you shake off the cobwebs?
The rain cools the earth
Do you ease other's pain?
The clouds provide shade
Do you lighten others' hurts?

The sun warms us
Do you keep your heart open?
Are you warm?
Do you brighten others' day?

Do you truth speak?
Truth speak
Be wide open
Be you

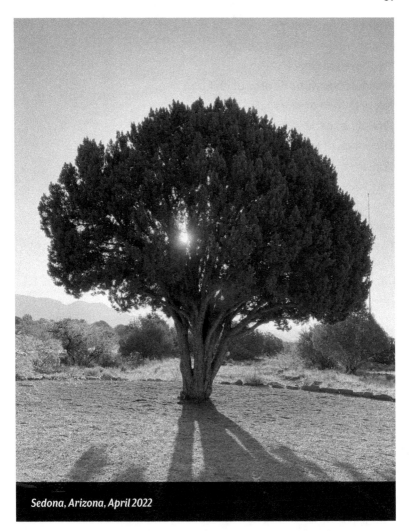

Sedona, Arizona, April 2022

Mama Tree

Father tree you stand proud reaching up to the sun

Your branches are thick

Rooted in love and productivity

Oh Mama Tree

Thank you for giving birth to us all

Your limbs are twisted
Intertwined with Mother Earth
You have scratches
You hold the wounds of your children
Keeping their dreams safe
Providing shade when we are hot
The winds of trauma blow through your leaves
You weep
You sway
You spread your roots out deep
Anchoring our lives when we are temporarily lost
Passing along messages of eternal love

Stone Drive

A grounding
A space to flourish
Stones absorb pain
Unearth poisons
Release all to the earth
Crystals and stones
Gai allows healing
Centered again

Ascension

Look up

Galaxy

Always near

Truth

Reach for it

Believe it

Nirvana

Creator connection

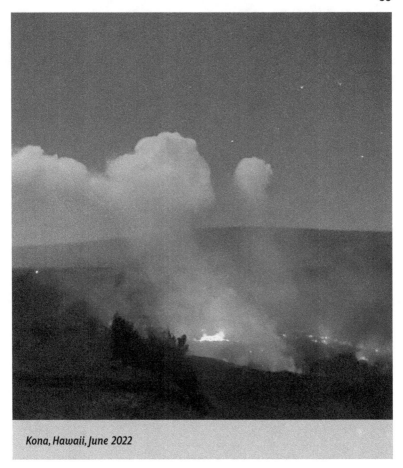

Kona, Hawaii, June 2022

Like Lava

A dark Kona night hike
The path wet with rain
Volcanic flares
Bursts of red lava
Flowing down the slopes
A brilliant glow
Under the moon and stars
Clouds moving so fast

Am I spinning?
Orbs showing in the photos
Am I seeing things?
Hearing shamans' messages?
Sacred, ancient, grounded
Oms chanted in respect
Are you spontaneous?
Are you flowing?
Create
Burst

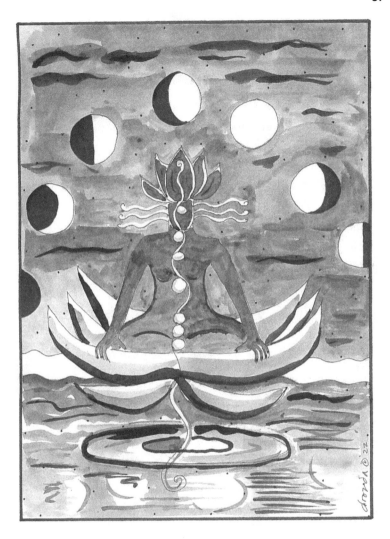

Moon Illumination

Magically close

Changing in the shadows

Shapeshifting

Eclipsing planets

Obscuring celestial bodies

Visible at night and day
Sometimes you hide
Like magic
A spotlight on the sea
Waves responsive
Tides and emotions ebb and flow
Women's menses respond
Fairy tale settings
Storytelling
All occur under your illumination
Plants and people rest when you shine
Holding our wobble steady
Gifting us with rhythm
Thank you moon!

Animals

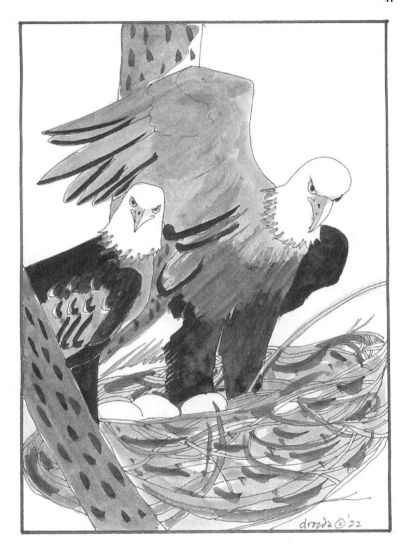

Birds

Sing with the sunshine
Wait patiently for the rain to stop
Food is plenty after every rain
Peck relentlessly without complaint
Fly, walk, and fish all day

Grounded energy
Take flight when needed
Share responsibilities
Build a beautiful home
When fledging occurs
Leave
No fear
It is time
Destined to be one with nature
Are you?

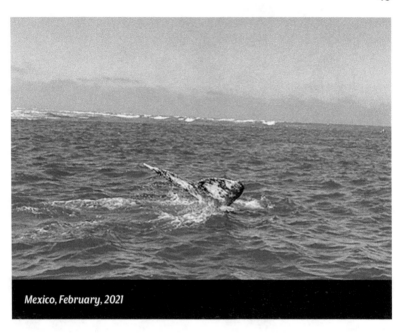

Mexico, February, 2021

Arrival

The whales know I'm coming
My son talks to them from afar
They will meet us on the water
Whispering telepathically that they are ready to
Welcome us
They speak the language of centuries
Love, hurts, and beauty
The water holds all our collective dreams, wishes, and magic
Wait, be still as our body chills awaken us to our past
And future
I feel moved to joyful tears that they celebrate me with
Their knowingness
Their earthly presence is appreciated and honored
Wise, large, and graceful gray whale
You stun me

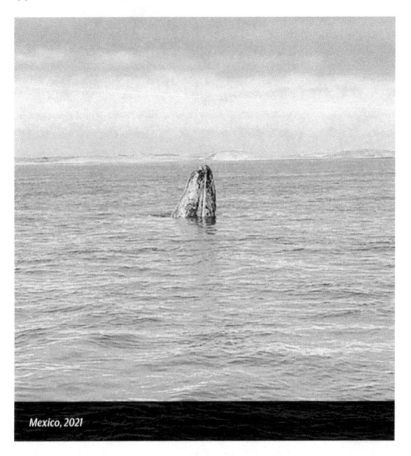

Mexico, 2021

Ballenas Gris

The ancient sages of the sea
Connected to nature
They have witnessed so many changes over time
Choose to stay connected to the moment
Each wave, each glimmer on the water
They live in a paradoxical world
Yet their reality is beautiful
Filled with playfulness and curiosity
Grateful

Reiki & Rumi, Sibling Love, January 2022

Pets

How they capture our hearts
Constant caressing
Ecstatic greeting
Tails wagging, wet kisses
Soft and silky hair
Playfulness
Mischief
Playing hard
Deep long sleep
Soulful eye contact
Wish they stayed with us longer
Shorter lifespan
Pleasant memories
Felt and remembered forever
Teaching us the simple truth
Love and loyalty
Truly enlightened

Spirit Guides

Alexander the horse
Your hair glistens and moves with the wind
You run beside me
Helping me create the movement I need to go forward

Lightening
Your long sheltie hair also moves with the air
You run on the other side of me
Whispering loving thoughts of encouragement
You teach unconditional love

Angelica
A wild, big cat
You are stealth
Unafraid
Can hunt, run, and prey/pray
You sustain the wind in my lungs

Orcas

You rise above the hurricane tides
Greeting me on the 8th floor
Calling out to me to open the sliding door
Calling me to swim, float, and dive with your family
Your chilling vibrations are words in my mind
I smile, unafraid and serene
A dream that was real
I go back to talk to you often
Orcas

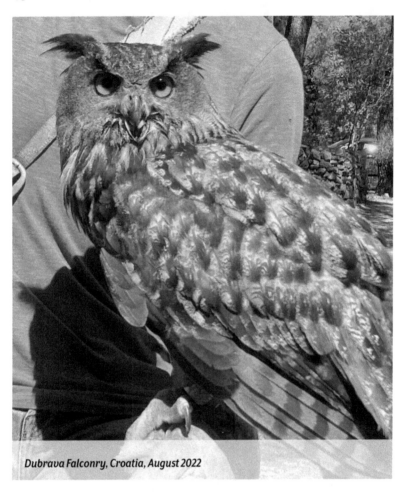

Dubrava Falconry, Croatia, August 2022

Meeting Today

Your golden eyes touched my soul
Large, luminescent, and all-knowing
Athena-like wisdom
Practical and wise
Feathers that are micro-turbulent
Layered to soar smoothly and silent
No screeching, just careful watching

A powerful neck rotation
You commanded the crowd and my respect
No fight or war was desired
Talons only used when needed
Holding on to your human Croatian friend
Hearing every crunch and sound above and below
Alert and always present
We can learn from owl

Self-Realization

Familiarity

A love so deep
Mistakes are forgiven
The ego must let go of
Hate, abandonment, and shame
Disappointment, abuse, trauma, and anger
Allow in
Bliss, laughter, and love
Be loyal
Pay close attention to your dreams
Regardless, we are here for our own journey
Some of us fight the trials
Reaching for whys
Act
Forgiving and cherishing
Start your day with unbridled joy
Enlightenment is the highest level of consciousness
Accept your role
Wonder and be

Live

Are you living?
Examine your energy
Lift your limitations
Cleanse your aura
Purge past memories
Jump for joy
Skip a bit when you walk
Nourish yourself
Get out in nature
Dip in the waters
Elevate your choices
Connect to your soul
Go there
Yes, go there!
Live your rhythm
Permission granted
Connected through all veils
Attract the miracle
Alive and spirited
Making history for your own soul

Distance

Adoring from afar
Touch and smell missed
Easier or harder
No land in sight
Serenity or fear
Simplicity comes
A different routine
New experiences
Another state
Another family
Another world
Stepping into a time warp

Habits

Rule or serve you
No choice is still a choice
Time moves forward
Regardless of wishes for it to stay the same
Bend, twist, and move if you must
But change

Pull Me Up

Pull me up light
A hit so deep it must be a lesson
A karmic irritation
Shudder with sadness, jealously, disappointment and
Anger
Pull me up

Help me connect to my higher, best, loving self
It doesn't matter in the big picture
There is no time
No limit to our soul's existence
Strengthen me

Avoid the lower reactions
Remove the gut-wrenching feeling
Connect to the solar plexus power
Pull me up

Focus on the big picture
Let the ugliness dissipate
Forgiveness, love, and gratefulness
The humanness of us all
No discussing or drama
Letting the energy engulf
Rays shine down absorbing the dark
Let the sunshine in
Let it go...focus
The light pulled me up

Mixed Up

Do not weaken your strengths with doubt
Shake off the dark and indecision
Connect to your intuition
Do not drift
The Libra, the Justice Arcana, and your senses can balance
Call upon your gods, guides, and the stars
Recognize karma and be fully aware
Reflect, decide, and be responsible for your actions
Respond and stand in your own light
Do not mix up your energy with others'
They are well-meaning but they are not you
You know yourself better than anyone else
If you stop and listen
Your insistence and persistence will prevail
Being clear can determine your next step
Being consciously aware moves in sweeping forces
Connecting you to powerful revelation and
A great change that invigorates hope and harmony
Another clear step into your brilliant future
To accomplish everything your heart loves

Shapeshift Consciousness

Channel from the earth

Limit the mass consciousness

Change and shapeshift

Your body

Your reality

Your thoughts

Connect to ancient energies

There are no lost treasures

Find your power

Scoop up the mysteries

Masters are waiting for you

Shapeshift to the stars

Shapeshift to your original home

Settle into your spirit animals

Ride, run, and explore with them

Activate all your DNA

Blending the male and female

Memories, magic, alien intelligence await

Travel to islands and galaxies

Overlook friends sleeping

Telepathically talk to the heaven bound

They and you are not lost

Shapeshift your consciousness

Serpent

You slither into my essence
Making sure I face and let go of my fears
Representing transformation
Shredding the old for the new
No name provided but deep and wise guidance

Which

Do you?
Inspire
Aspire

Which do you give?
Empathy
Sorry

Which do you mean?
Intention
Attention

Are you?
Unconditional love
Constrained

Are you?
Wise
A ruler

Do you?
Hope
Wish

Do you choose?
Belief
Fear

Do you practice?
Forgiveness
Resentment

Are you?
Fulfilled
Empty

Are you?
Generous
Stingy

Are you?
Powerful
Limited

Are you?
Passionate
Lazy

Is your essence?
Expansive
Restricted

Are you?
Visionary
Follower

Do you bring?
Sunshine
Rain

Evolve

You are here to evolve your spirit
This is your only true purpose
Not your title(s) or career
Not as a parent or as a partner
There is no time
Only perceptions
Strive only for perfection in love and compassion
Stay open to messages and synchronicity
Connect with your own essence
We are one
Manifest, create, and evolve
Your actions mirror your consciousness
Let it all go
Relax into the universe
Release
Evolve

Garbage

Are you aware of what you store inside?
Take the garbage out
No storing is necessary
Let the unwanted go
Better yet, don't collect it to begin with
Holding on to experiences
Only lessens your current day
Enjoy each moment
Experience today
The glory is in the present
Now

Eternal

Earth school for now
Flesh with a soul
Collecting insights each day
Your aura expands
The soul lives
Your essence is eternal
It expands with each transition
Celebrate all life

Warrior

Inside
Deep
Find
Passion
Wisdom
Proceed
Spin gold
Warrior

Wrap It Up

Wrap up your ego
Give it as a present to spirit
Full self-realization requires presence
Be intentional
Wrap up your worries
Wrap up your excuses
Wrap up your past
Wrap up your image
Present them to nature and God
Gifted weaknesses allow joy to take you over
Your willingness allows
The new to take over
You feel free
Your being is wrapped up like in the womb
Warm, supported, growing, and full only of wonder
Wrap it up

Make an Impact

Impact

Yours

Others

Find it

Dig in

Express it

Change

Evolve

Witness

Shake it up

Again and again

Impact

Light Reflection

Rays, sparkles, and illumination
Awareness shining into eyes
Warming skin
Opening hearts
Tears streaming down cheeks
Gleaming reflections
That split second of glimmer
Exultating consciousness
Even for a moment
Harmony
Even for a moment
It matters
You matter

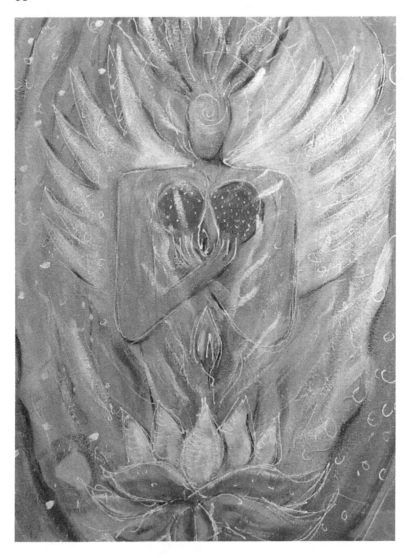

Soul Soaring

Your truth
With integrity
Inner devotion
Be devotional

Ignore the static
Light up your chakras
Honor your path
Find a way
Celebrate you
Be significant
Now and in transition
Soul Soar

Spirit

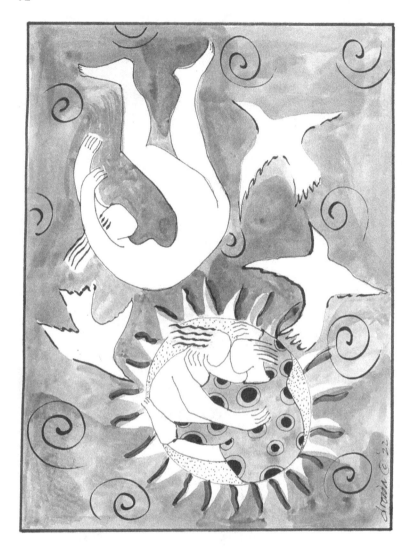

Transition

Tumbling through the atmosphere
Light and etheric
Unknowing but knowing
Feeling peaceful with the quiet hum

Spirit guide is it you?
Suddenly familiar faces
Filled with deep love
No pain
So light
Life review
Choices that were made
Lessons avoided
Lessons learned
Experiences taken
Experiences avoided
Unconditional love
Fondness all around
Eager to do it again
You are home

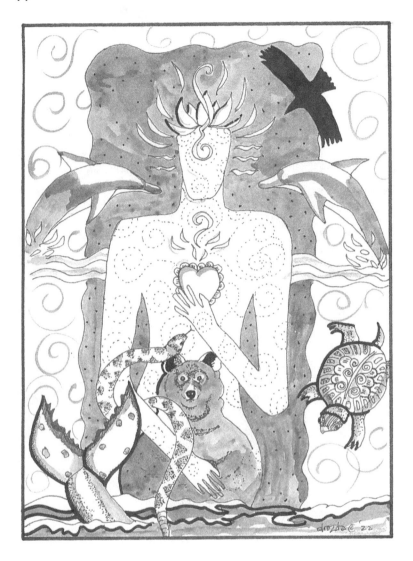

Reach Into Your Dreams

Reach into your dreams
Unleash the mystical
The goddesses and gods are there
Mermaids, unicorns, and angels

Believe in your spirit guides
Talk to your animals
Bear, snake, whale, dolphin, eagle, and turtle all have messages

Reach into your dreams
Connect to Lemuria
Travel over other sleeping souls
Through galaxies
Say hello to their consciousness
Spread warmth, healing, and love

Reach into your dream
Feel the moment
Open your heart wider
It's easier in the dreamtime
Remember your purpose
Spread it

Reach into your dreams
Retire from unhappiness
Outshine yesterday
Rejuvenate your vibration
Wake with passion
Fulfill your promises
Fulfill your contracts

No Worry

The tulip fields along the beach side
They always wait for us
Connect our spirits at different times
You're always there when I call you
You hold my head in your lap
Reassuring me you are OK
My spirit guide stands by if needed

Reminding me you're watching over us
You are exploring awakened and at home
You're not ready to come back yet but you know you will soon
Not discouraged from your last earth experience
Reviewing, questioning, and setting up your next earth journey
Attuned to your true sage self
There is no need for worry in any space or time
Find it while on earth
Compassion for humanity and yourself
Your cells hold history and the truth

Third Eye

We all have one
Unifying and clarifying our existence
Be still to open and connect to it
Awaken and strengthen intuition
Feel and see the signs
Visions of truths
Chakras flow and vibrate
People are drawn to your aura
Sensitive to your asking
The dark and light comfort you
Enveloping your spirit
Third eye honing
Magnetic experiences follow

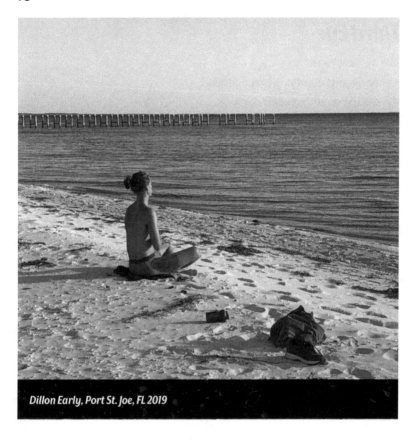

Dillon Early, Port St. Joe, FL 2019

Be

Be aware
Be guided
Be thankful
Be grateful
Be delighted
Be joy
Be inspired
Be aligned
Be enlightened
Be one

Greatness

Pinpoint your greatness
Hone in and develop it
Share it
Spread your message
Expand your intuition
Envelope your wisdom
Into your heart
Into hugs and care packages
Change your world then
Magnetize and uplift others
With your gifts
Your presence can be the present
Greatness expands

Going where everybody avoids
To never-ending serenity suppression

Getting ready
Evolve angelica talisman
Navigate eternal and surreal serenity

Doors

The light is there
Are your doors opened or closed?
Some doors need to be closed
While others newly opened
To let the new in
The old must be released
When the spirit is restless
Doors need closing
Knock down that door if needed
When creativity needs fuel
Open new doors
When the heart feels angst
Open another loving door
Allow transmuted new energy in
If too many doors are cracked open
Ask permission for closure
Doors can indicate new beginnings
Walk through them to experience
A new fresh place, garden, and world
Treasure the newness

Out There

They are out there
Our past souls
Loved ones who are home
The ancient wise ones

They reach out to us
In dreams
In the sky
In meditation
In prayer

Be aware
Be open
Listen carefully
The air and vibration bring messages
Not lost
Just forgotten or perhaps
Hidden to help us learn

Touch your soul
You are in there
We are one

Wise One

At the top of the stairs through the mist
You await me any time I climb to ask my questions
All-knowing and patient
Unlike other guides you imbue a HEAVY energy
You told me once that you hold all the heartache of
The universe
Love flows like ribbon robes around you
You are strong with enveloping energy
A vibration so strong I can't hug you yet
Someday I will be attuned enough

New Guide

A guided meditation with
Sandra with no last name
I float above my body fully awake
Counting to 10
Seeing me being greeted by Mayan
Mayan greets me
It's August 2021
Eyes brown
Yet his eyes change to brilliant blue and then to tiger
Eye stones and jade green
Surrounded by mountains so green
Peru? Yes Peru!
Arms held straight out to me
Healing is just a veil away
"Let it all go", Mayan whispers through the current
The pain caught in your heel is real
Release and heal
Release and heal
One tear of understanding flows down my left cheek
Belief and joy permeate my body
What is next?
He slips away
Count to 10

Jesus Angel

You welcomed me in my first deep meditation
You opened your arms to me in a red tulip field
Flexible stems bending to the waves in front
You ask me to put my head in your lap
You stroke my head and hair
Telepathic messages passed between us
True peace

Whole/Holy Place

Temple

Shrine

Sanctuary

Alter

Peace

Profound memory

Heavens

Home

Earth

All one

Love

It Is You

Recognize
Remember
A DNA so familiar
The code is present
Lemurian
Pleiadean
Shaman
Mermaid
Teacher
You do know!
We are waiting
Connect
See me
See you
I see you
Mu

Enchanted

Shamanic

Trust your intuition

No waiting

No studying

No discussing

No denying

Play in Spirit

You are enchanted

Seven Sisters

So high you sit
Sparkling
Shining your light
Guiding masters
Whispering
Drumming
Energy helpers
We hear your messages
Echoes of the past, present, and our future
Signs
Signals
Pay attention
Soak up their messages
Feel the chills
Acknowledge their presence
Seven Sisters

Portal

Find yours
An opening to guidance
A door to greatness
Loving power
You are splendid
Use your heart to guide
Evidence is stored within
Creative light
Just waiting
Absorb the light
Spread the light
Be the sage

Resources

Ask and be open
People and guides wait for you to ask
Seek tools
Crystals, stones, cards, incense, and candles
Numbers, stars, and planets
Speak to your animals
Channel the energy
Energize
Be magnetic
Look within
Your inner medicine awaits
Dance
Celebrate

Circles

Bring community
Memory
Ring-a-round the rosy
Wheels
The four directions
Your inner compass
Awaken

CPSIA information can be obtained
at www.ICGtesting.com
Printed in the USA
JSHW010549070423
40020JS00007B/104

9 781513 698922